FROM THE FILMS OF

Harry Potter

✶✶✶

THE
TIME-
TURNER

✶✶✶

Contents

"You mean we've gone back in time?"

—Harry Potter

Harry Potter and the Prisoner of Azkaban

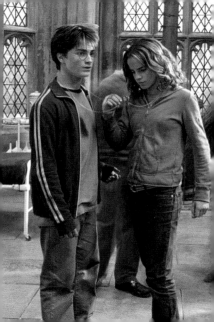

Introduction

——◦◦⟶✦◆✦⟵◦◦——

Travel back in time to the Harry Potter film series and explore one of the wizarding world's most mysterious devices: the Time-Turner. As seen in *Harry Potter and the Prisoner of Azkaban*, this magical device transports any witch or wizard into the past, allowing them to attend multiple classes at the same time or change the course of history itself. But beware! The Time-Turner is not without significant dangers and consequences. In the words of Hermione Granger, "Awful things happen

to wizards who meddle with time." So don't delay! Discover the rules, limitations, and behind-the-scenes film facts about the Time-Turner . . . before time runs out.

> ## "Mysterious thing, time."

—Albus Dumbledore

Harry Potter and the Prisoner of Azkaban

The Time-Turner

The Time-Turner's delicate—and uniquely
fashionable—appearance contrasts its perilous
power. This ornate, golden necklace contains
a small, enchanted hourglass. Spinning the
hourglass within the necklace sends its wearer
into the past, an hour for each revolution.
When designing the Time-Turner for the film,
the graphic artist looked to real astrological
instruments like the astrolabe for inspiration.
Considerations like discreteness (Hermione
had to be able to hide it!) and wearability also
influenced the design.

• HOURGLASS •

The key component of the Time-Turner. The
hourglass contains an Hour-Reversal Charm
initiated with a single revolution of the device

• GOLDEN CHAIN •

The Time-Turner device works on any
witch or wizard who wears the golden chain
around his or her neck.

• INSCRIPTION •

In *Harry Potter and the Prisoner of Azkaban*
Hermione's borrowed Time-Turner
includes an inscription:

*I mark the hours every one
nor have I yet outrun the sun
My use & value unto you
are gauged by what you have to do*

GOLDEN
CHAIN

INSCRIPTION

OURGLASS

"When in doubt, I find retracing my steps to be a wise place to begin."

—Albus Dumbledore

Harry Potter and the Prisoner of Azkaba

Hermione and the Prisoner of Azkaban

<div style="text-align:center">❖ ◦•◦ •❖• ◦•◦ ❖</div>

The Time-Turner plays a critical role in *Harry Potter and the Prisoner of Azkaban,* the third film in the Harry Potter series. Throughout, Hermione has a lot on her plate. Between her never-ending studies and an animal-related feud with Ron Weasley, it would seem that she has little time for extracurricular activities (i.e., saving the wizarding world with her friends). But when Hagrid's Hippogriff,

Harry Potter, and Sirius Black need help, Hermione reveals a secret: the Time-Turner. Turns out, this gift from Professor Minerva McGonagall comes in quite handy for taking three time-conflicting classes at once—and for saving friends. At the gentle urging of Professor Dumbledore, Hermione heads back in time (along with a dumbfounded Harry) to save Buckbeak the Hippogriff, repel a Dementor attack at Black Lake, and release an imprisoned Sirius Black.

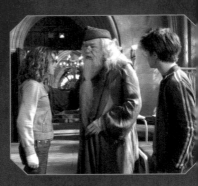

"This is how I've been getting
to my lessons all year."

—Hermione Granger

Harry Potter and the Prisoner of Azkaba

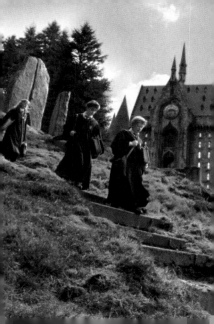

SERIOUS CONSEQUENCES

❖━━━◦━━━━✦◦✦━━━━◦━━━❖

Traveling into the past is not without some serious consequences. In fact, as Professor Dumbledore states in *Harry Potter and the Prisoner of Azkaban,* "The consequences are too ghastly to discuss." Although vague about the potential ramifications, Dumbledore does specify one way to avoid them: "You must not be seen." During their time travels, Hermione reiterates this law to Harry.

Thankfully, with some quick thinking—and some even quicker hiding—the two return safely to the present day.

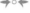

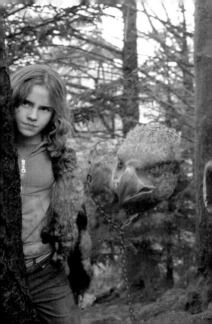

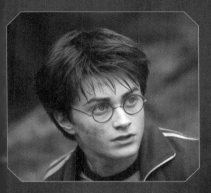

"This is not normal."

—Harry Potter

Harry Potter and the Prisoner of Azkaban

CLOSE CALL

Hermione and Harry's time travels were not without a close call—or two. During one of their trips into the past, the duo follows their former selves to Hagrid's pumpkin patch. While looking on from behind a cluster of trees, Hermione comments on her past self's hairstyle: "Is that really what my hair looks like from the back?" The lighthearted moment is quickly interrupted when Hermione's past self spins around, catching a glimpse of her future self. Thankfully, past-Hermione is quick to

dismiss what she sees, stating, "I just saw ... never mind." A close call, indeed.

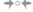

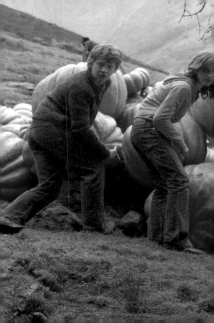

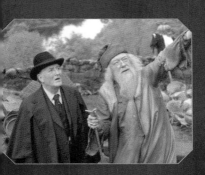

"Remember what Dumbledore said. If we succeed, more than one innocent life can be spared."

—Hermione Granger

Harry Potter and the Prisoner of Azkaban

A TIME TO REMEMBER

Souvenirs often represent a time worth remembering. While filming *Harry Potter and the Prisoner of Azkaban,* actor Emma Watson, who plays Hermione Granger, took a few souvenirs from the film set—with permission, of course. She admits to taking three things: her cloak, wand, and . . . the Time-Turner.

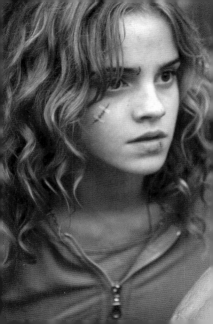

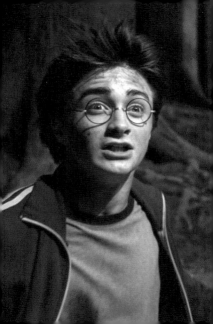

"What just happened?"

—Harry Potter

Harry Potter and the Prisoner of Azkaban

ALL-TIME FAVORITE PROP

❖ ◇ ❖ ◆ ❖ ◇ ❖

The Time-Turner prop was an all-time
favorite of many cast and crew members
on *Harry Potter and the Prisoner of
Azkaban*, including the film's producer,
David Heyman. During a press conference,
Heyman and others were asked about
their favorite props from the making of
the Harry Potter film series. Heyman
chose this magical time-traveling device,

ating, "The Time-Turner for many, many asons." Responding to the same question, ctor Emma Watson replied that Heyman lready stole her answer! No doubt, a prop near and dear to her heart as well.

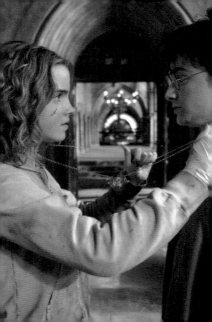

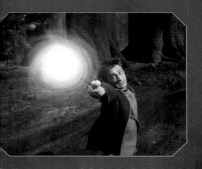

"I knew I could do it this time
cause, well, I'd already done it."

—**Harry Potter**

Harry Potter and the Prisoner of Azkaban

LEARNING
FROM THE PAST

❖ ─◦─ ◦─►◦◄─ ◦ ─◦─ ❖

When hundreds of Dementors attack
Harry and Sirius Black at the edge of Blac
Lake, Harry attempts to stop them with
his Patronus Charm. Unfortunately, it is
no match for the onslaught. Then, just as
Harry is about to succumb to a Dementor
Kiss, a bright light flashes from across the
lake, and a Patronus in the form of a stag
appears, fending off the Dementors. Harr
believes that somehow his father has save

hem. However, later in the film, Harry and
Hermione return to this same moment via
the Time-Turner. Harry watches the scene
unfold and soon realizes that it was him—
his future self—who conjured the lifesaving
Patronus. Once again, Harry steps forward
and unleashes a Patronus spell upon the

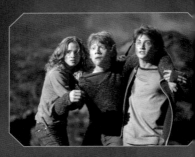

"How could somebody be in
two places at once?"

—Harry Potter

Harry Potter and the Prisoner of Azkaba

Dementors. Harry's Patronus takes the form of a stag, just like his father's.

TIME-TURNER TRIVIA

IN THE NICK OF TIME

❖ ◦ ▸ ◆ ◂ ◦ ❖

"You would do well, I feel, to return before
this last chime," Albus Dumbledore tells
Harry and Hermione before they travel
back in time. After rescuing Buckbeak,
saving Harry's past self, and releasing
Sirius Black, the duo hears the chimes
sound. Quickly, they race back to the
Hogwarts' Hospital Wing, arriving just as
their former selves disappear as the last
chime rings. The time loop closes and all
is well—except for a thoroughly confused

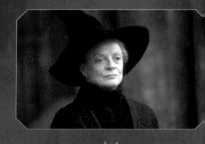

Professor Minerva McGonagall

(and still injured) Ron.

Who gave Hermione her Time-Turner device?

A. Professor Albus Dumbledore

B. Harry Potter

C. Professor Minerva McGonagall

D. Peter Pettigrew

Turn the page to find out!

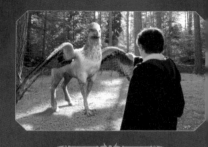

Hippogriff

What fantastic beast do Harry and Hermione save using the Time-Turner?

A. Acromantula

B. Hippogriff

C. Unicorn

D. Phoenix

Turn the page to find out!

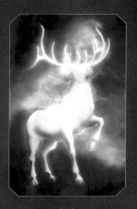

Stag

This book has been bound using
handcraft methods and
Smyth-sewn to ensure durability.

The jacket and interior were
designed by Justine Kelley.

The text was written
by Donald Lemke.